MAJESTIC EXPRESSIO...

Relax, Refresh, Renew

D1048808

New Every Morning

INSPIRATIONAL ADULT COLORING BOOK

BroadStreet
P U B L I S H I N G

THIS
BOOK
BELONGS
TO

BroadStreet Publishing Group LLC
Racine, Wisconsin, USA
Broadstreetpublishing.com

MAJESTIC EXPRESSIONS

NEW EVERY MORNING
© 2016 by BroadStreet Publishing

ISBN 978-1-4245-4924-5

Cover design by Chris Garborg | garborgdesign.com
Compiled and edited by Michelle Winger | literallyprecise.com

Printed in the United States of America.

16 17 18 19 20 21 22 7 6 5 4 3 2 1

INTRODUCTION

There is plenty of research that shows coloring to be an effective stress reducer. Maybe you picked up this book because you've heard the hype and you're curious. Perhaps you've been looking for a way to relax. Now you have your very own adult coloring book, and you have every reason you need to sit down and color. And perforated pages make it easy for you to frame your favorites!

Coloring is a great distraction from all you have going on, but the best way to find lasting peace is to spend time with your Creator. Fill these intricately designed illustrations with the beauty of color as you dwell on the richness of his Word, the faithfulness of his character, and the depth of his love for you.

Happy coloring!

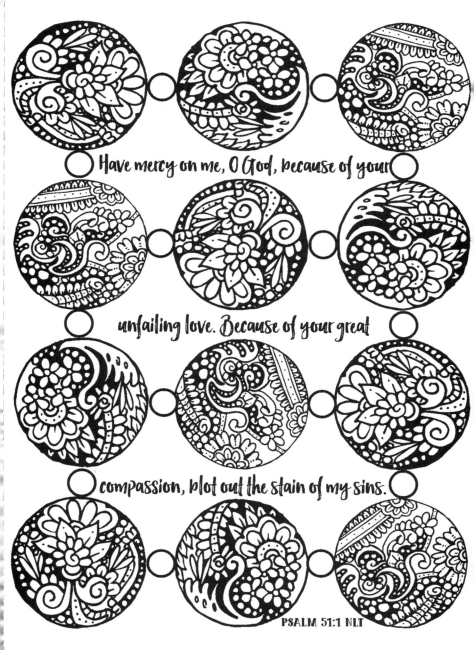

Have mercy on me, O God, because of your unfailing love. Because of your great compassion, blot out the stain of my sins.

PSALM 51:1 NLT

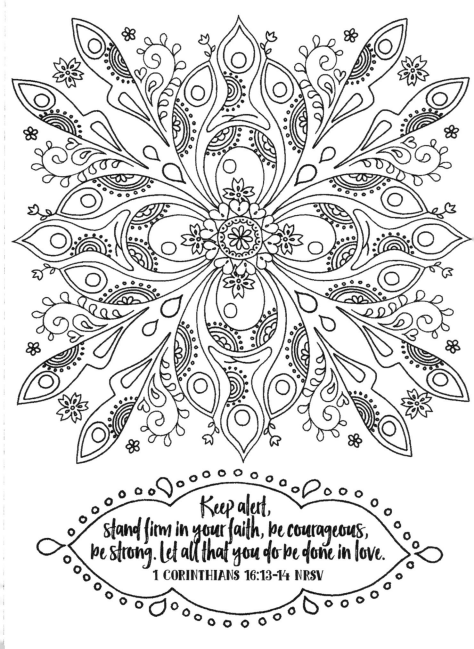

Keep alert,
stand firm in your faith, be courageous,
be strong. Let all that you do be done in love.
1 CORINTHIANS 16:13-14 NRSV

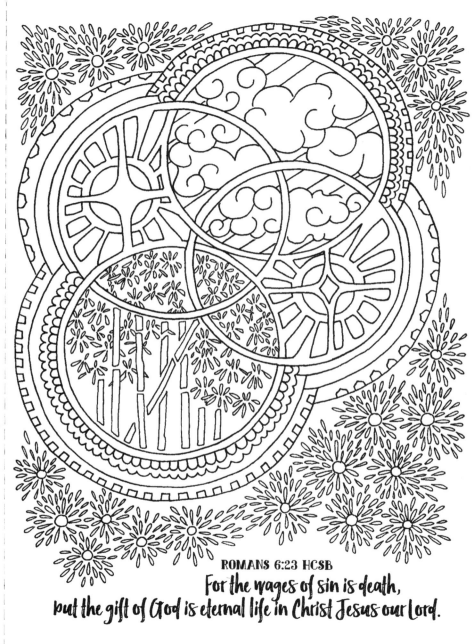

ROMANS 6:23 HCSB
For the wages of sin is death,
but the gift of God is eternal life in Christ Jesus our Lord.

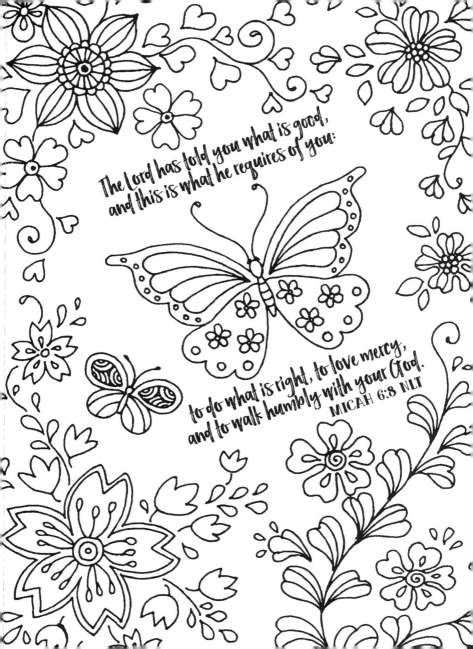

The Lord has told you what is good,
and this is what he requires of you:
to do what is right, to love mercy,
and to walk humbly with your God.
MICAH 6:8 NLT

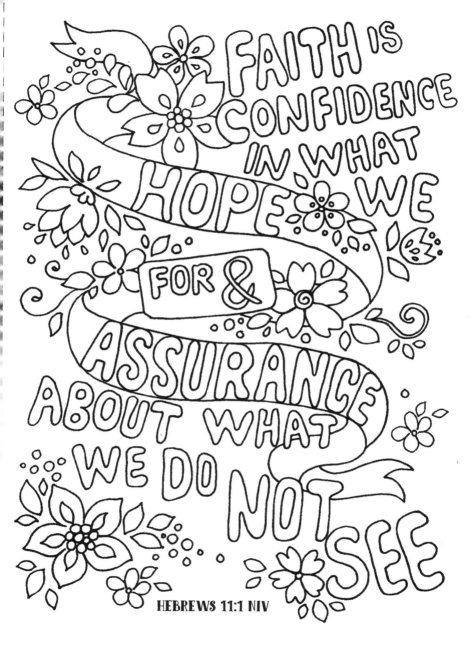

FAITH IS CONFIDENCE IN WHAT WE HOPE FOR & ASSURANCE ABOUT WHAT WE DO NOT SEE

HEBREWS 11:1 NIV

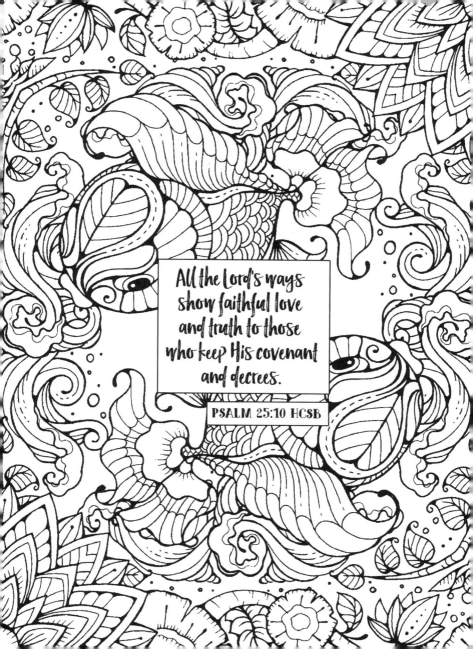

All the Lord's ways
show faithful love
and truth to those
who keep His covenant
and decrees.

PSALM 25:10 HCSB

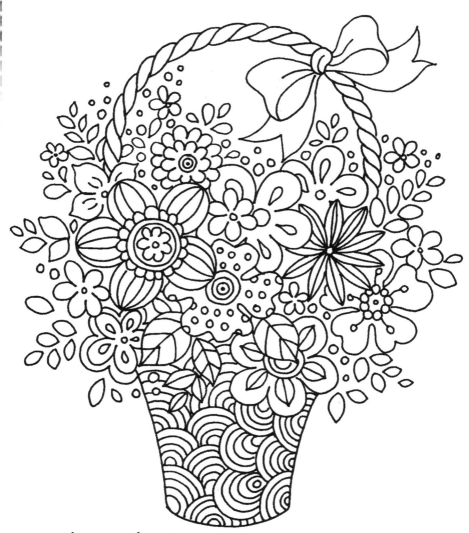

I will be faithful to you and make you mine,
and you will finally know me as the Lord.

HOSEA 2:20 NLT

Hope
does not disappoint,
because the love of God
has been poured out in our hearts
by the Holy Spirit
who was given to us.

ROMANS 5:5 NKJV

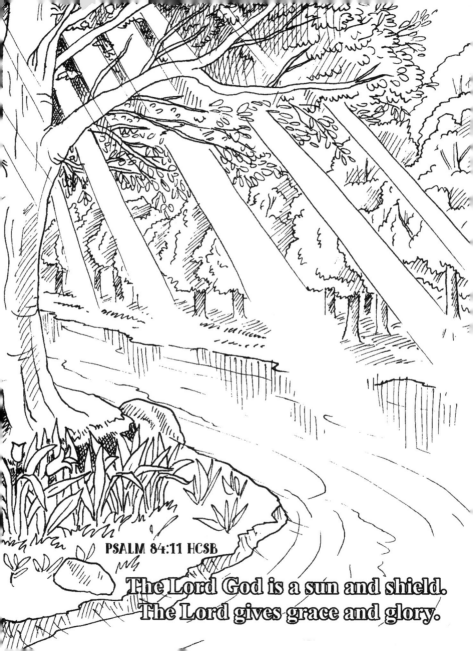

PSALM 84:11 HCSB

The Lord God is a sun and shield.
The Lord gives grace and glory.

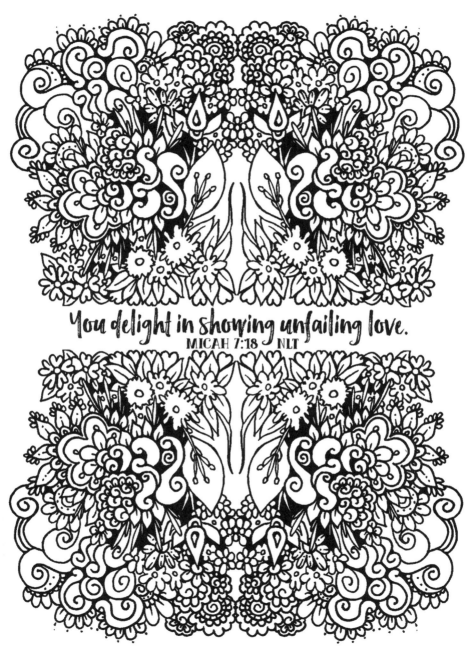

You delight in showing unfailing love.
MICAH 7:18 NLT

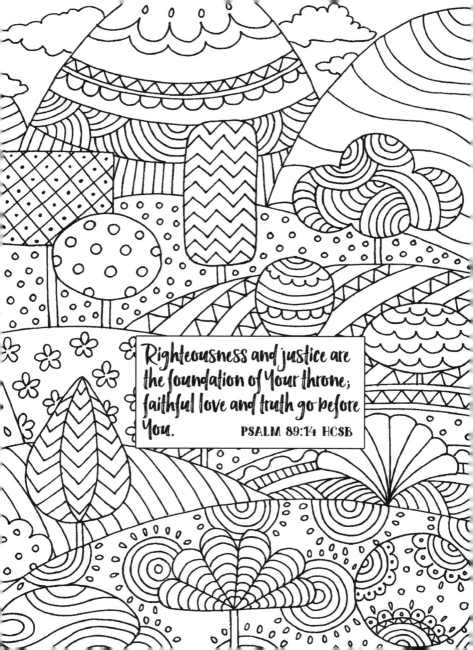

Righteousness and justice are the foundation of Your throne; faithful love and truth go before You.

PSALM 89:14 HCSB

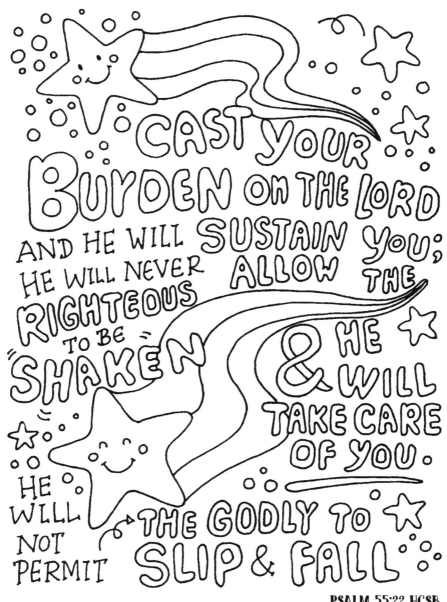

CAST YOUR BURDEN ON THE LORD AND HE WILL SUSTAIN YOU; HE WILL NEVER ALLOW THE RIGHTEOUS TO BE SHAKEN & HE WILL TAKE CARE OF YOU. HE WILL NOT PERMIT THE GODLY TO SLIP & FALL

PSALM 55:22 HCSB

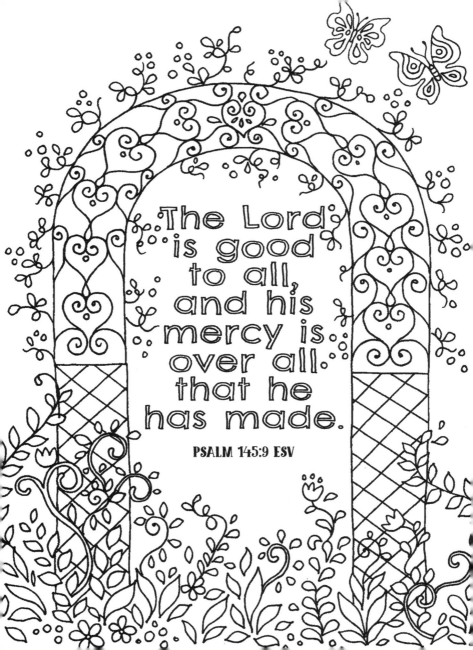

The Lord is good to all, and his mercy is over all that he has made.

PSALM 145:9 ESV

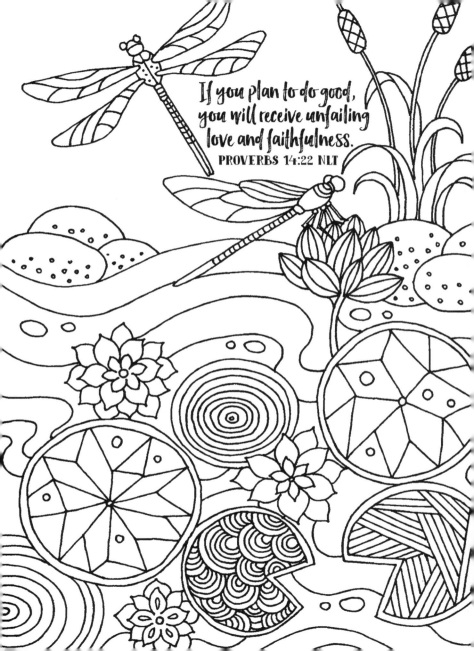

If you plan to do good,
you will receive unfailing
love and faithfulness.
PROVERBS 14:22 NLT

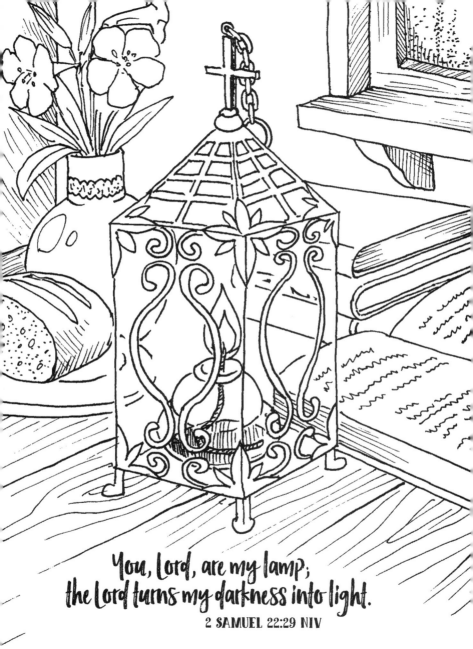

You, Lord, are my lamp;
the Lord turns my darkness into light.

2 SAMUEL 22:29 NIV

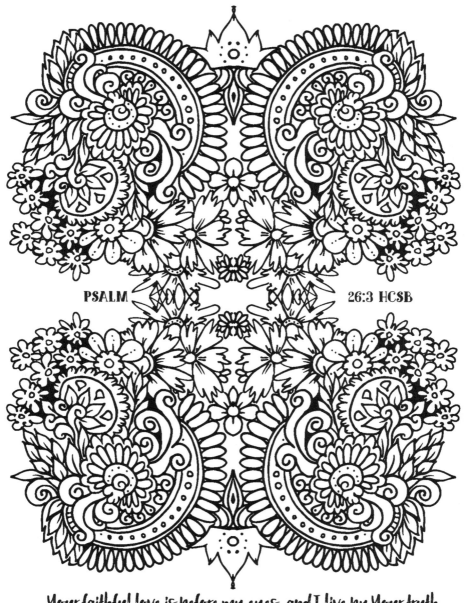

PSALM
26:3 HCSB

Your faithful love is before my eyes, and I live by Your truth.

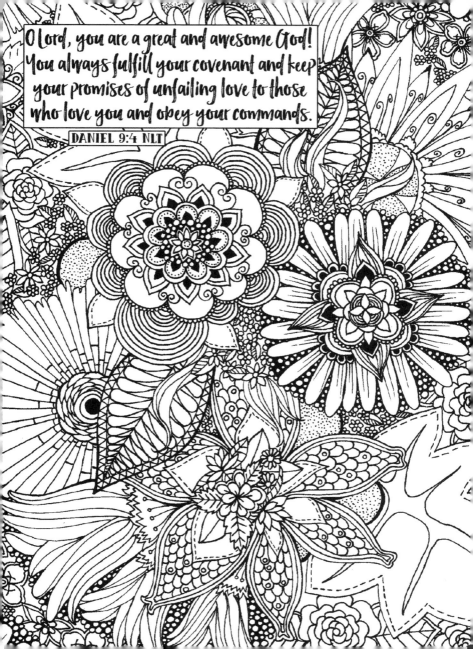

O Lord, you are a great and awesome God! You always fulfill your covenant and keep your promises of unfailing love to those who love you and obey your commands.

DANIEL 9:4 NLT

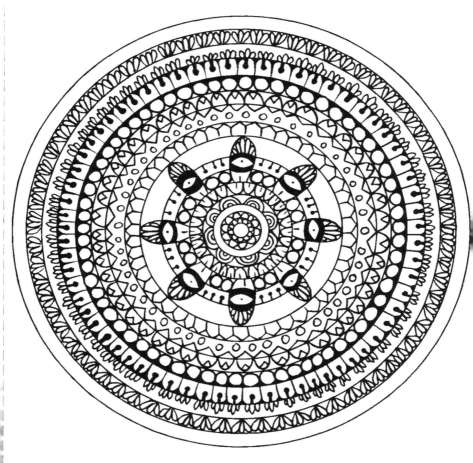

PSALM 145:17 NIV

THE LORD IS RIGHTEOUS
IN ALL HIS WAYS AND
FAITHFUL IN ALL HE DOES.

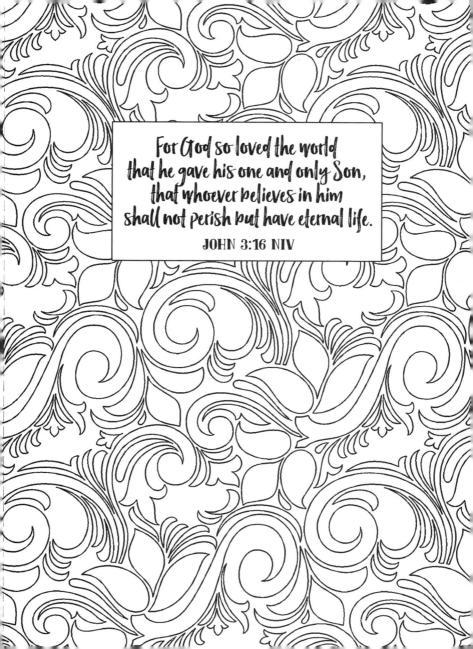

For God so loved the world
that he gave his one and only Son,
that whoever believes in him
shall not perish but have eternal life.

JOHN 3:16 NIV

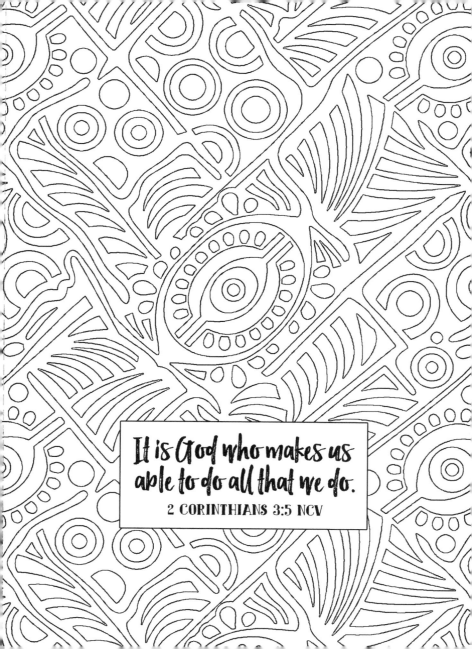

It is God who makes us
able to do all that we do.

2 CORINTHIANS 3:5 NCV

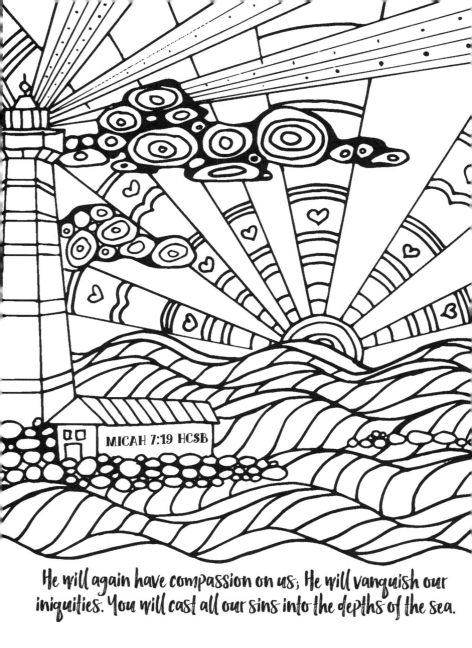

MICAH 7:19 HCSB

He will again have compassion on us; He will vanquish our iniquities. You will cast all our sins into the depths of the sea.

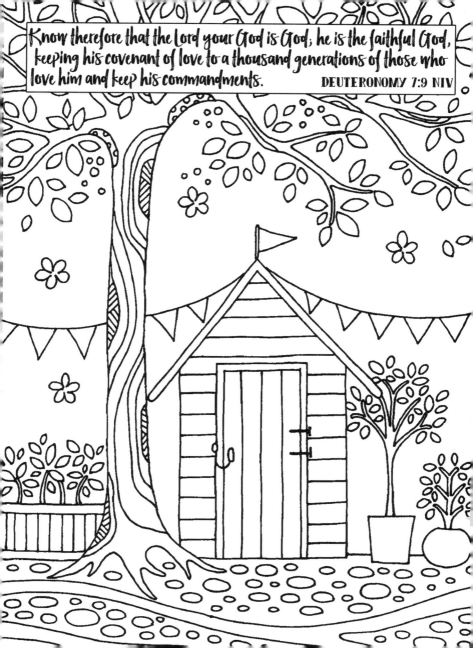

Know therefore that the Lord your God is God; he is the faithful God, keeping his covenant of love to a thousand generations of those who love him and keep his commandments.

DEUTERONOMY 7:9 NIV

The Lord longs to be GRACIOUS to you,
And therefore He WAITS on high to have COMPASSION
on you.

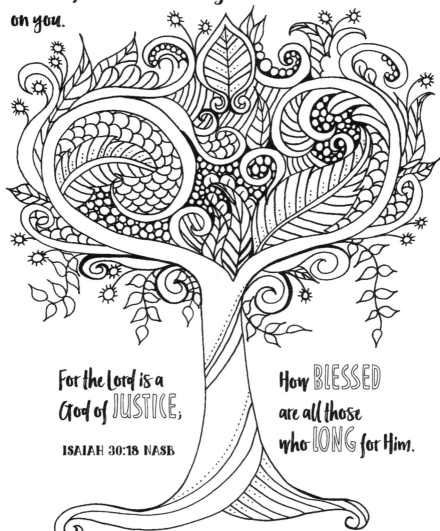

For the Lord is a
God of JUSTICE;

ISAIAH 30:18 NASB

How BLESSED
are all those
who LONG for Him.

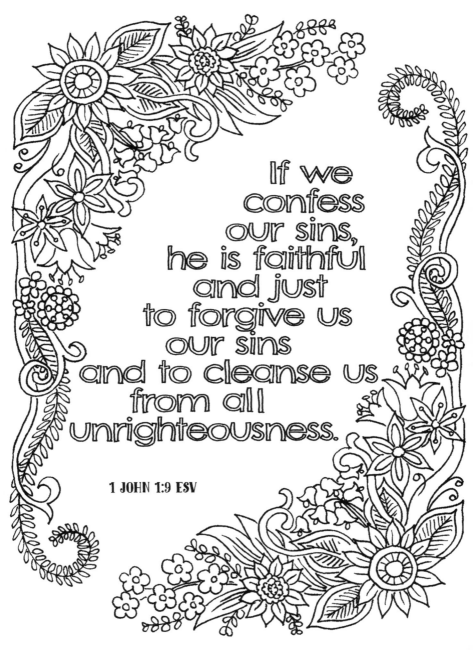

If we confess our sins, he is faithful and just to forgive us our sins and to cleanse us from all unrighteousness.

1 JOHN 1:9 ESV

FOR YOU ARE SAVED BY GRACE THROUGH FAITH,
AND THIS IS NOT FROM YOURSELVES;
IT IS GOD'S GIFT

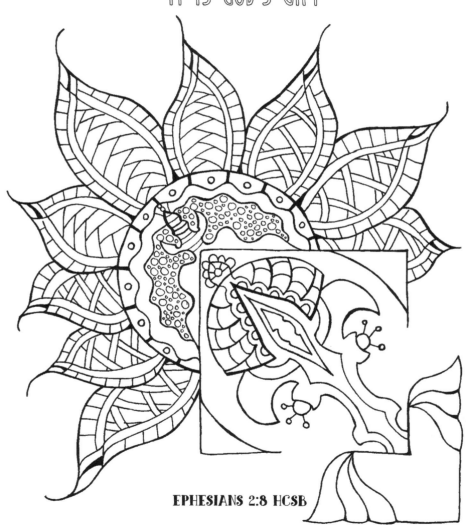

EPHESIANS 2:8 HCSB

God is so rich in mercy, and he loved us so much, that even though we were dead because of our sins, he gave us life when he raised Christ from the dead.

EPHESIANS 2:4–5 NLT

You, O Lord, are good and forgiving,
abounding in steadfast love
to all who call upon you.

PSALM 86:5 ESV

If anyone is in Christ,
the new creation has come:
The old has gone, the new is here!

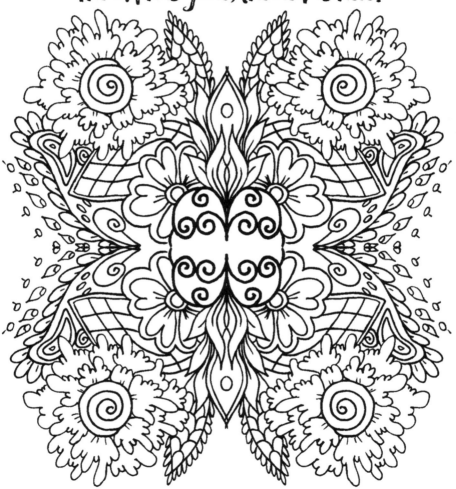

2 CORINTHIANS 5:17 NIV

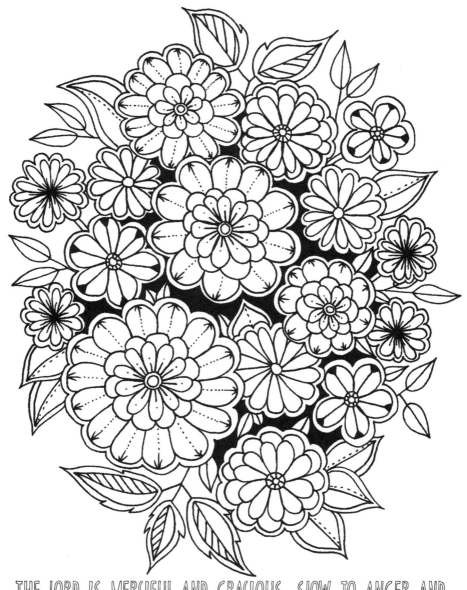

THE LORD IS MERCIFUL AND GRACIOUS; SLOW TO ANGER AND
ABOUNDING IN STEADFAST LOVE.

PSALM 103:8 NRSV

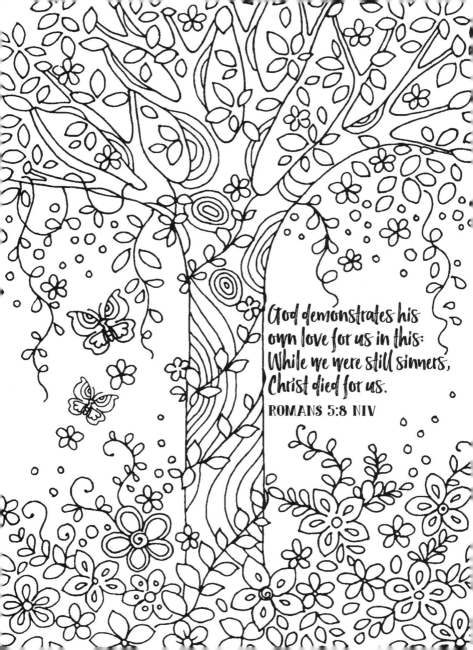

God demonstrates his own love for us in this: While we were still sinners, Christ died for us.

ROMANS 5:8 NIV

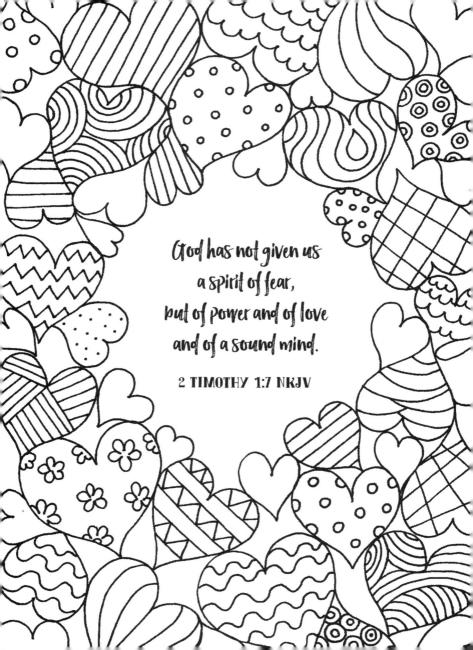

God has not given us
a spirit of fear,
but of power and of love
and of a sound mind.

2 TIMOTHY 1:7 NKJV

HE HAS MADE EVERYTHING BEAUTIFUL IN ITS TIME

ECCLESIASTES 3:11 NIV

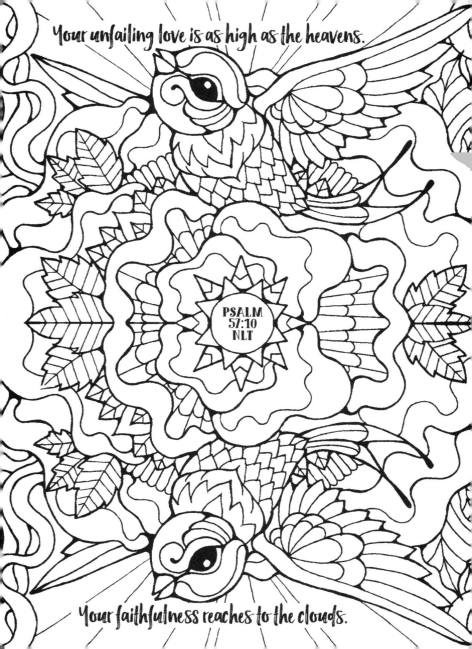

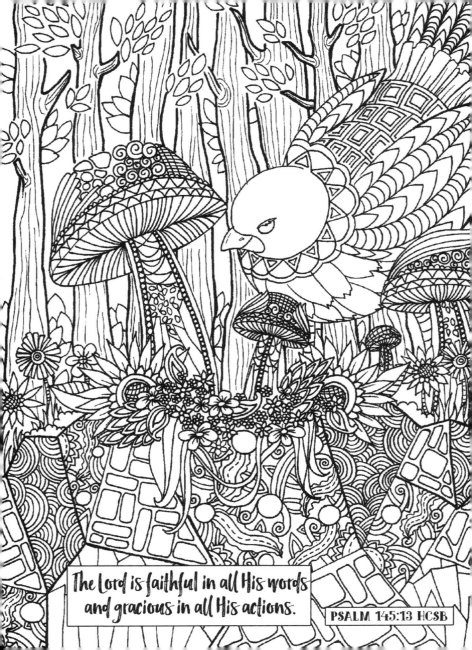

The Lord is faithful in all His words and gracious in all His actions.

PSALM 145:13 HCSB

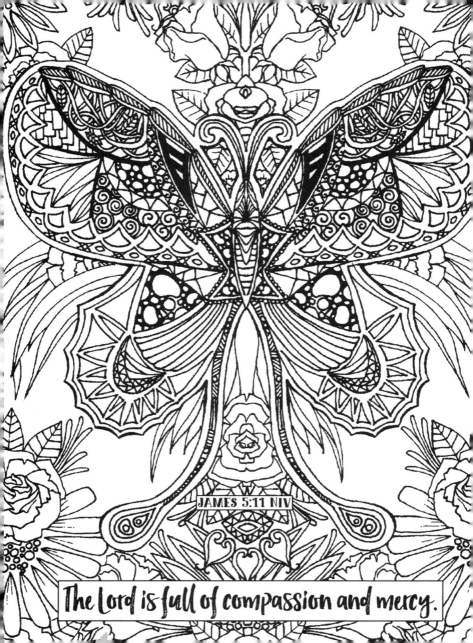

JAMES 5:11 NIV

The Lord is full of compassion and mercy.

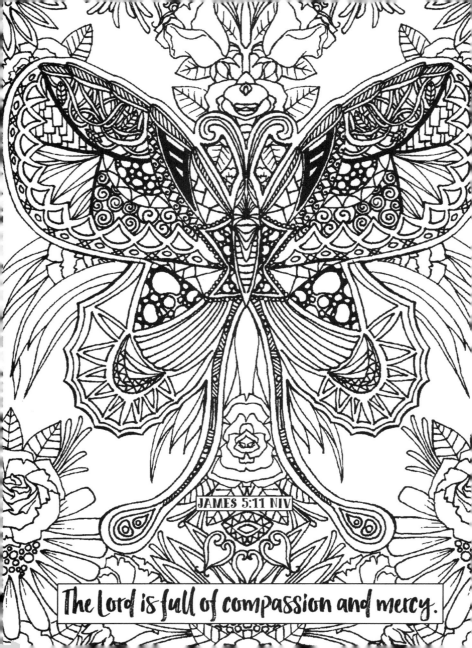

JAMES 5:11 NIV

The Lord is full of compassion and mercy.

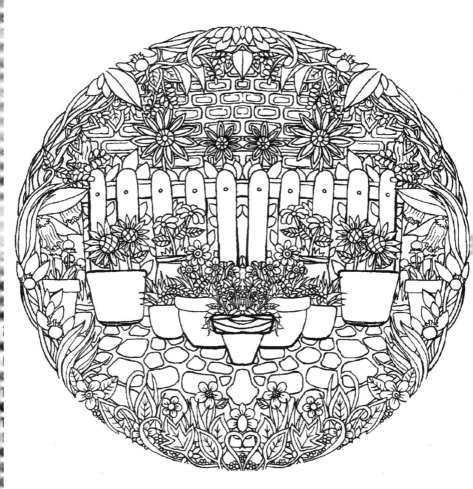

FOR THE LORD IS GOOD;
HIS STEADFAST LOVE ENDURES FOREVER,
AND HIS FAITHFULNESS TO ALL GENERATIONS.

PSALM 100:5 ESV

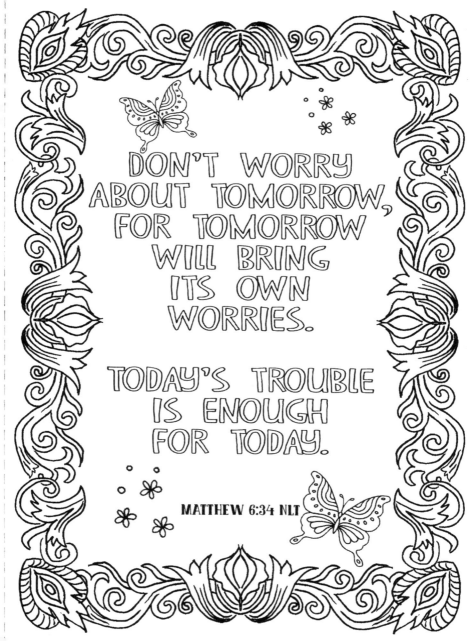

DON'T WORRY
ABOUT TOMORROW,
FOR TOMORROW
WILL BRING
ITS OWN
WORRIES.

TODAY'S TROUBLE
IS ENOUGH
FOR TODAY.

MATTHEW 6:34 NLT

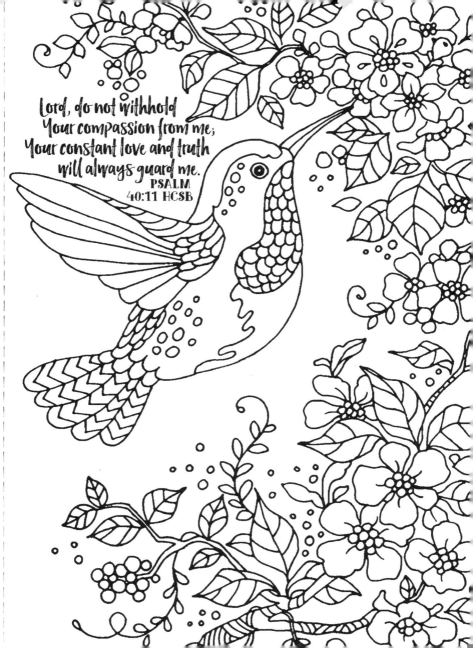

Lord, do not withhold
Your compassion from me;
Your constant love and truth
will always guard me.
**PSALM
40:11 HCSB**

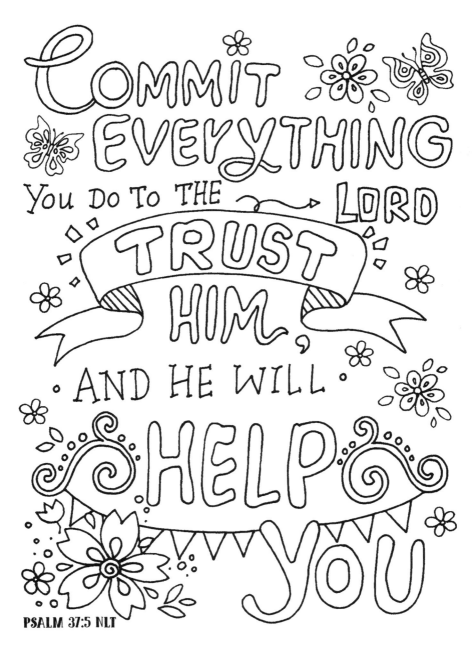

Commit EVERYTHING You Do To THE LORD TRUST HIM, AND HE WILL HELP YOU

PSALM 37:5 NLT

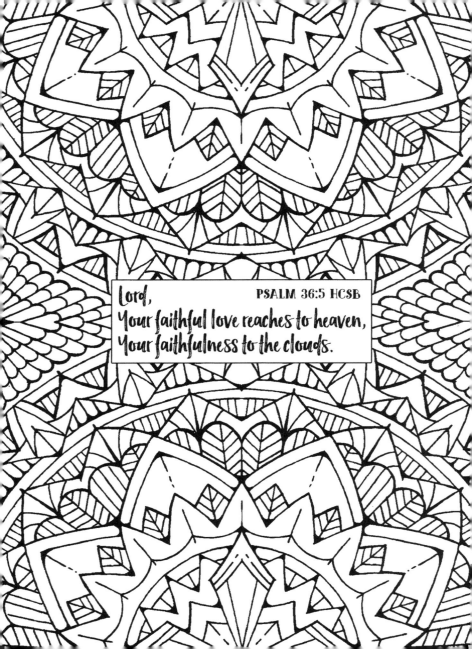

Lord,
Your faithful love reaches to heaven,
Your faithfulness to the clouds.

PSALM 36:5 HCSB

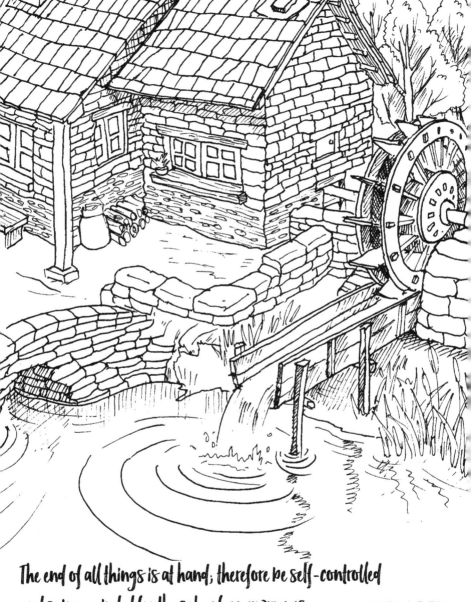

The end of all things is at hand; therefore be self-controlled and sober-minded for the sake of your prayers. 1 PETER 4:7 ESV

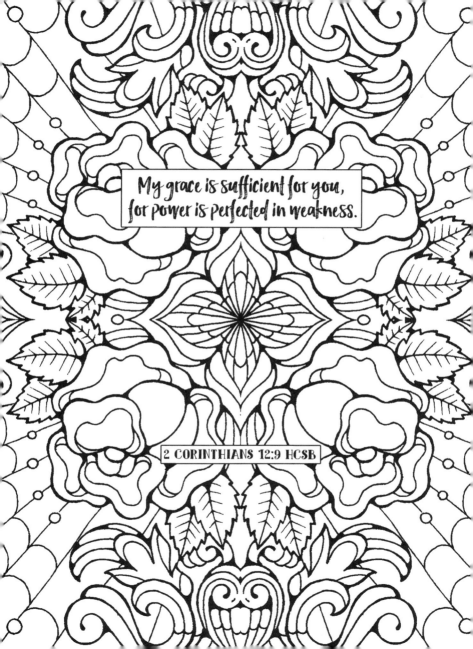

My grace is sufficient for you,
for power is perfected in weakness.

2 CORINTHIANS 12:9 HCSB

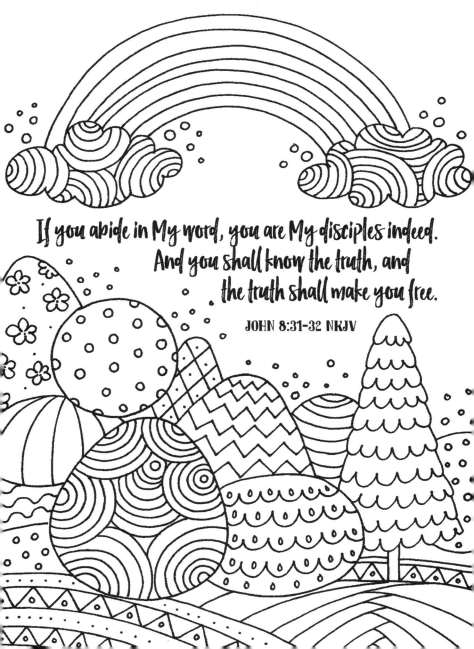

If you abide in My word, you are My disciples indeed. And you shall know the truth, and the truth shall make you free.

JOHN 8:31-32 NKJV

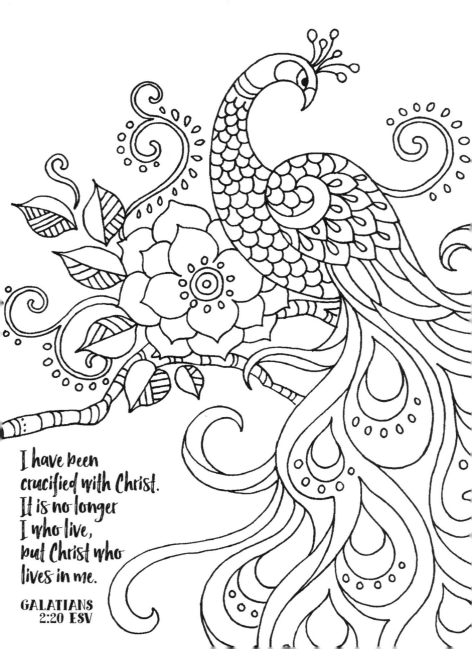

I have been
crucified with Christ.
It is no longer
I who live,
but Christ who
lives in me.

**GALATIANS
2:20 ESV**